Vanilla, Cinnamon, and Dark Chocolate

THE COLOR OF LOVE

Edwina Louise Dorch

VANILLA, CINNAMON, AND DARK CHOCOLATE
THE COLOR OF LOVE

iUniverse books may be ordered through booksellers or by contacting:

iUniverse
1663 Liberty Drive
Bloomington, IN 47403
www.iuniverse.com
844-349-9409

ISBN: 978-1-6632-3405-6 (sc)
ISBN: 978-1-6632-3404-9 (e)

Library of Congress Control Number: 2022909190

Print information available on the last page.

iUniverse rev. date: 06/24/2022

To my daughter Nichole,
the most beautiful cinnamon-colored
"phenomenal woman" I know

"A Room Full of Sisters"

Jugglers of professions, managers of lives—
mothers of children, lovers and wives.

They were good-hearted and kind, reaching out to others;
giving back to the community and
supporting our brothers.

A room full of sisters, like jewels in a crown:
vanilla, cinnamon, and dark chocolate brown.
—Mona Lake Jones

Contents

Preface

In an essay that appeared in her 1983 book, *In Search of Our Mothers' Gardens*, Alice Walker defined colorism as a practice of discrimination by which people with lightest skin are treated more favorably than those with darkest skin. Colorism determines who gets ahead, who gets convicted, and who gets elected. Colorism also influences health, wealth, and opportunities for success.

Books such as *The Color Complex* and *Shades of Difference: Why Skin Color Matters* are academic works that explore the concept of colorism, and *Passing*, *The Darkest Child*, and *The Dark-Skinned Sister* are novels about it. This contemporary urban novel explores the lives of three women and the inferiority complexes associated with colorism.

Can the average woman overcome her unconscious negative self-talk, low self-esteem, and the accompanying anxiety and depression? Can she achieve self-acceptance and find love and happiness?

Join the *Vanilla, Cinnamon, and Dark Chocolate* on their journey to self-regard and well-being.

Chapter 1

The murky gray elevator doors parted on the ground floor of the Los Angeles Department of Children and Family Services, and a cinnamon-colored woman stepped out.

"Hey, Sonnie." A Hispanic guard the height and width of a doorway nodded at the woman. He stood with one hand rubbing the side of his mustache and the other resting on his pistol.

"How you doin'?" She patted him on the arm, displaying even ivory teeth. Her black-and-white silk scarf fluttered at her side as she walked, filling his nostrils with the warm aroma of Tatiana perfume.

He wondered if she was part Native American as he admired her long and shapely legs. Her high cheekbones and the straightness of her spine suggested that she had been a clever and strategic warrior in a prior life, but the dimples in her cheeks challenged that idea. Her face changed daily, like a picture he'd seen in a psychology class at night school. The picture was of a beautiful or ugly woman depending upon the way one turned their head or the features they

concentrated on. These were contradictory features: sweet and sour, hawk and dove, saint and sinner.

Sonnie stepped inside a compartment created to protect county workers—an area made of plaster at the bottom and glass at the top. A wiry, ashy, frog-faced woman in a matted wig sat on an elevated stool, phone receiver to her ear and a frown on her face. Hugging the woman's shoulders, Sonnie leaned over and spoke into her microphone.

"Lisa Steel." Sonnie heard her own voice magnified as she looked out into a sea of dazed and sour faces. The room was filled with row after row of haggard people sitting in gray metal chairs, waiting for various kinds of government assistance—food stamps, medical stickers, and bus passes.

Lisa, a dark chocolate woman, stood, dressed in black stretch pants and a yellow sleeveless blouse. Her black-and-gold braids swung in her face as she wrestled with a toddler held in her arms. Her full mahogany lips, which were perpetually parted, showed a gold-rimmed front tooth among an otherwise perfect set of thick ivory teeth. Three gold pinhead earrings lined her ears, and her inch-long plastic fingernails were painted metallic blue.

Her baby's father, Frankie, sat next to her, dressed in heavily starched and creased khaki pants, a black Banlon shirt, and a pair of soft Bally loafers. His hair was not tight, dry curls but loose, wispy-looking ones. His long, thin upper lip was outlined by a mustache of equally fine black hair. Arms across the backs of the chairs on either side of him, legs spread wide, and a toothpick in his mouth, he eyed Lisa's

round hips and thin waist with pride and possessiveness as she walked to the interview room.

The people in the room reminded Sonnie of film versions of European immigrants on boats fleeing to America. They wore odd combinations of clothing: black dress pants combined with white high-top tennis shoes, orange velvet jackets paired with green corduroy pants, and tan bell-bottom suits matched with red knit hats.

As she waited for Lisa at the entrance to the interview room, an ebony-colored man with a Haitian accent entered behind his social worker. As he passed by her, she inhaled his pungent body odor. Overwhelmed by his odor, she dropped her pencil and reached to get it. She smelled urine near the wall and recoiled. An elderly Mexican woman in a red scarf, flowered apron, and black leather boots picked Sonnie's pencil up and handed it to her.

"Gracias, Abuela." She bowed her head, thanking the woman.

"De nada." The woman returned a toothless grin, breathing gin into Sonnie's face.

Lisa approached the door of the interview room where Sonnie stood waiting. Lisa and Frankie had recently become Sonnie's clients when a hospital had reported them to the department. The hospital's report indicated that their baby had ingested cocaine and gone into a forty-eight-hour coma. Frankie had been taking care of the boy at the time. He claimed that he had taken the baby to the park, and when he wasn't looking, the baby had picked the substance up off the ground and ate it. A bystander in the park at the time verified the veracity of the incident.

In Sonnie's first session with the couple, Lisa was silent. Frankie answered in monosyllables only. "Yes, no, when, and why." None of their responses were useful in determining if they used cocaine themselves.

"How you doin'?" Sonnie asked, handing the eighteen-month-old boy a small box of raisins.

"I'm OK, Ms. Black." Lisa sounded weary. "How you doin'?"

"Fair to middlin'." Sonnie used a southern expression from her father and led Lisa through a corridor created by plywood partitions. She stopped at an empty interview space and took a seat on one side of an old, gray military desk. Lisa sat on the other.

Lisa had finished high school, even though she was pregnant throughout her senior year and worked part of the time. She wasn't currently working and didn't seem to have skills. Thus, Sonnie had asked the county vocational education program to assess Lisa's math and verbal skills and to determine whether she could be trained to earn a living. Lisa had come in to find out her test scores.

"I've got good news. You scored in the 80th percentile on both the English and math tests you took. Such scores mean you wouldn't have to take remedial classes to get into a local community college or training program if you want."

"I can't believe it. I haven't studied in so long. But …" Lisa lowered her eyes. A Naomi Campbell looking woman, she had very distinct mannerisms. She lowered her eyes when she was embarrassed, covered her mouth when she laughed aloud, and put her hand on her ample breasts when she was startled.

"But what?" Sonnie did not understand her hesitancy.

"It's just that he's so young …" Lisa kissed the top of the boy's head. "And I want him to know me as his mother, not … not some other woman."

Sonnie remained silent for a moment. "Lisa, you've got to be able to earn a living. What if something happens to Frankie?"

Lisa's eyes remained lowered, and Sonnie considered her braided extensions and plastic fingernails. Both looked as though they were professionally done, which would cost a lot of money. Lisa glanced at the test sheets.

"Trust me." Sonnie squinted to communicate the earnestness of her plea.

Sonnie's words were in English, but they might as well have been in Spanish based on the confusion in Lisa's face. Sonnie turned her head to one side, wondering if Lisa understood her message.

"I'll think about it," Lisa whispered as she stood up to go.

Disappointed that she hadn't been able to convince Lisa to ask for a college or job application, Sonnie walked behind her as she reentered the waiting room. Frankie narrowed his eyes, looking from Lisa to Sonnie as if he had overheard their conversation. Lisa lowered her eyes, but Sonnie glared at him defiantly.

His harsh gaze made Sonnie shiver. To calm the fear she felt, she patted the guard's arm as she passed him, glancing at Frankie. Her silent adversarial message to him was clear. In the next instant, however, she tried to cancel her adversarial thoughts, remembering that the twelve disciples were charitable toward strangers.

"Satan, may the Lord rebuke you," she whispered to herself, struggling to overcome her mother's unsympathetic nature. Where did the cocaine that the baby ingested come from? Was Lisa or Frankie a drug addict? She had chosen to focus on Lisa, but perhaps Frankie was the good one and Lisa was the bad one, not vice versa.

Sonnie glanced down the hall as she stepped out of the elevator and onto the second floor. For the first time, it occurred to her that there was nothing of interest to look at. A sweaty, metal water faucet was the only thing in the hallway. The county only had enough money to acquire the building, phones, and desks for social workers and nothing else, but Sonnie wanted more.

She wanted a private office where she could see clients—a carpeted office full of pale green ferns and thick, dark green rubber plants. She wanted Georgia O'Keeffe paintings and Stan Getz jazz samba playing softly in the background. She shivered as she stepped into a room created to hold a gaggle of social workers. The air conditioner, which had not been working all summer, now decided to blow forty-degree air into the room. The county electrician, who was standing on top of a coworker's desk, taped cardboard over the air vents, apparently unsure of how to turn the system off. From memos circulated by their union stewards, Sonnie suspected he was doing this because he was unwilling to go into the ceiling crawlspace, fearful that he might encounter asbestos.

The room contained rows and rows of gray, metal post-war military desks, metal file cabinets, and metal bins

filled with foster parent agreement forms, court petitions, dispositions, and adjudication forms. At one end of the room, a gigantic and noisy copy machine spewed paper into the air while unattended. At the other end was the receptionist's desk, behind which hung a wall-size map of the city.

She was trying to decide which Georgia O'Keeffe painting she would hang in her private community-based office one day and had narrowed her choice down to *Black Iris* rather than *Jimson Weed*.

Musing about O'Keeffe paintings, she didn't notice when Tyrone walked in. The color of blackberries, he stood over six feet tall and had limbs as long and straight as sugarcane. He strolled with a light foot, his head turning from side to side as he walked. He never looked at other men, even when he chatted with them. Women lowered their eyes when they saw him. His court reports were always late, but he was muscular enough that his male clients hesitated to threaten him and playful enough that children were charmed by him.

He strolled by Sonnie's desk and bent down to tie his shoelace, admiring her sculpted legs and slender ankles. She pretended to focus on her case files, ignoring him. Unperturbed, he smiled broadly at her and moved on, strolling toward their clerk's desk at the far end of the room.

The woman who assembled and downloaded their court reports was a honey-colored woman with dyed brown-and-blond streaked hair. She wore tight skirts, V-neck silk blouses that exposed jelly-like cleavage, and three-inch heels. It was rumored that she'd shot her husband because she found him in bed with her sister. The rumor caused everyone in the

office to fear her, but Tyrone leaned over her desk and put his face close to hers.

"What you want?" she snapped.

"I don't know. What you got to offer?" he replied.

"What type of court report is it?" she asked, ignoring his sexual inuendo.

"Adjudication," he replied.

"Out of luck. I need to download an adjudication for Sonnie and a petition for Steve before I can do anything else," she resisted. Tyrone said nothing. Instead, he admired the V-neck of her bodice until, embarrassed, she grabbed the papers from his hand.

"I'll try," she said abruptly and began to shuffle papers around on her desk.

"I appreciate it." He smiled slyly at her.

"Yeah, yeah." She stood up and headed for the hallway.

Sonnie overheard their conversation and saw Tyrone manipulate the typist. She could feel her mother's temper simmering inside her. "Be quiet and be still." She tried to discipline herself as she tapped her fingers on her desk and her temper began a slow boil. She needed to move to manage her negative thoughts and decided to go to the cafeteria to get some chewing gum, a vice she felt was less harmful than potato chips or candy. She stomped down the hall.

Just before she arrived at the entrance to the cafeteria, she glanced over her shoulder and saw Tyrone walking behind her. She stopped and turned to face him, unable to subdue her anger.

"You know, my report, which was submitted according to required court time frames, will be delayed so that your

report, which was submitted late, can be downloaded for tomorrow's court docket."

"You know, I forgot my report was on the court docket for tomorrow," he said.

"Mm-hmm." She hesitated. To say more could be construed as bickering and thus unfeminine. But maybe if she didn't ethically roll her head, snap her fingers, or raise her voice she could get away with challenging his behavior.

"I was listening to your conversation with the clerk just now, and I've overheard your conversations with her before. You're manipulative."

"I asked her to type a court report for me. How did I use her?"

"Do you truly believe that's all that happened between the two of you just now?"

"Yes."

"Then you either need to see a counselor or a spiritual healer." She clicked her tongue and started to walk away. He put his hand on her arm to stop her.

"Why do you say that?"

"Because you no longer see the manipulativeness of what you do," she said firmly.

"I'm manipulative?" he asked.

"Yes, you are."

"And you're not?"

"I suppose everyone is to some degree."

"But you're not?" he asked.

"No, not very."

"Then why are you wearing earrings? Lipstick? Perfume?"

"For the same reason people put ornaments on a Christmas tree," she said.

"Do you truly believe that's why you wear all that stuff?"

"One hundred percent."

"Then you either need to see a counselor or a spiritual healer." He was cleverer than she thought.

"I gon pray for you," she chided him.

"So, you're a Christian?"

"And not ashamed of it."

"Well, you should invite me to your church ... try to convert me."

"OK."

"Say when."

She stalled and looked away. "How about Sunday? Where do you live?" she asked before he could ask for her address.

"I'll write it down for you." He stopped at one of the cafeteria tables and wrote down his address.

"I'll pick you up around ten thirty. Service starts at eleven."

Leaving the cafeteria, she wondered if she was ready to get involved with a man again. While finishing the last semester of her master's degree program, she had been *gobsmacked* by a wispy-haired, caramel-colored poet who was also an English professor. He had thin lips and smooth hands and wore monogrammed shirts, cuff links, vests, and privately tailored suits.

The two met in the cafeteria every afternoon, and he gave her books he thought she should read and quoted poetry he had memorized. He read her papers before she submitted them and gave her advice about how to improve them. He

told her which classes she should take and counseled her on which ones fulfilled her graduation requirements. She daydreamed about him when he wasn't with her, and she bought him gifts to indicate her affection.

After midterm, he began inviting her to his house, which wasn't far from campus. He was a connoisseur of wine, and though she did not drink, he began to teach her how to distinguish one type of wine from another. His lessons involved tasting wine, which made her sleepy, and while she was drowsy, he slipped inside her from the back before he drove her home. Although she didn't like this type of intimacy, she was afraid if she didn't yield to his coarse desires, he would give his attention to one of her classmates who would.

They did not see each other during the three weeks of winter break. So, at the beginning of the spring semester, when he sent invitations for his wedding to graduate students and faculty in the department, she was all but psychiatric. The classmate he chose to marry was a young woman who glided, rather than walked; whose vanilla-colored skin was so clear, it appeared to have a glistening veil over it; and whose *Mona Lisa* smile seemed permanently glued to her Caucasian-featured face.

Heartbroken, she dropped all her classes, realizing her kaleidoscope features and church and charity social circles could not compete with an upper-class vanilla woman whose father was also a member of the academy who could, undoubtedly, help the poet's career. She stayed in the attic of her parents' house for the rest of the spring semester and the following summer, losing weight and developing dark circles under her eyes.

As Labor Day approached, she lay on a twin bed in the

attic reading *For Colored Girls Who Have Considered Suicide / When the Rainbow Is Enuf* by Ntozake Shange. She was reading the lady in green lament,

"somebody almost walked off wid alla my stuff"

when she heard her father climbing the stairs to the attic. He paused when he reached the top of the stairs.

"I've decided to give my ole card table to the church," he said as he walked across the room and grabbed one side of the table and moved it forward. Then he grabbed the other side of the table and moved it forward before he stopped and took his handkerchief out of his pocket and wiped the sides and back of his neck. The summer sun covered the roof, and the attic was sweltering.

"Sonnie, a good man is a man who helps you and makes you feel good about yourself. If your poet did this, you should mourn his loss. But if he didn't, come down out of this attic." She said nothing and instead pondered his statement.

The poet had not made her feel good about herself. So why exactly was she lamenting his loss? She watched a sparrow hop from one limb to another outside an attic window before she stood and lifted one end of the table to help her father carry the table down the stairs. That afternoon, her father drove her to campus, and she enrolled for the final semester toward her graduate degree.

Was Tyrone a good man according to her father's criteria? Would he help her and make her feel good about herself? Four years after her affair with the fair-haired poet, she would use her father's criteria to decide.

Chapter 2

The sun attempted to penetrate the stained-glass windows of the church, but instead, it created a rainbow of colors at the top of the chapel. A blue-eyed, Warner Sallman depiction of Jesus hung on the wall underneath. Baby's breath surrounded red roses in front of the podium. Sonnie's pastor stood at the podium, chiming in at calculated stanzas of the song and the choir stood like a flock of penguins, dressed in black robes with starched white collars swaying back and forth, singing mournfully,

> I haven't got all that I should.
> I haven't got all that is good.
> But the failure's not in God.
> It's in me. It's in me.

Ushers, wearing pristine white gloves, stood on the right, left, and in the middle aisles, waiting to walk parishioners to walnut-colored pews.

Women gave the evil eye to young children who were unable to sit still. Men fanned themselves absentmindedly.

The familiar smell of pressed hair and Posner's hair grease filled the room. Her pastor's sermon, from Galatians, was on what it meant to crucify the flesh. Sonnie glanced at Tyrone, wondering what the Crucifixion meant to him. He must have felt her looking at him and smiled slyly without returning her gaze.

After church, Sonnie and Tyrone walked to the lobby, where her mother was serving cookies and punch. A replica of Leonardo da Vinci's *The Last Supper* hung on the wall behind her with a Caucasian Jesus in the middle of his disciples.

Sonnie's mother had been her Sunday school teacher, and although she no longer taught Sunday school, she rose at six o'clock every Sunday morning to bake dozens of cookies for the congregation. And she didn't confine her charitable giving to Sundays or to their middle-class congregation. Every Monday, she and other female members of the church's auxiliary helped at the Mission, a faith-based organization on skid row, in downtown Los Angeles. The Mission provided clean clothes, food, and showers for the homeless in the city, of which there were thousands.

From childhood, Sonnie had accompanied her mother when she distributed food boxes to families in Watts at Thanksgiving and Christmas, and the joy on the children's faces when they discovered her and her mother on their doorsteps with turkeys, cakes, and cookies was one of the reasons she became a social worker. Yet her mother's character wasn't simple. She was frequently critical of poor people's hygiene and their physical characteristics.

"Hi, beautiful." Her father walked up from behind her and kissed her cheek.

Vanilla, Cinnamon, and Dark Chocolate

Her father was a mailman. On Saturdays, he, her brother, and a group of deacons from their church volunteered for Habitat for Humanity, a nonprofit housing ministry that built, repaired, and renovated hundreds of low-income homes for low-income residents. On Sunday afternoons, her father played dominoes with her younger brother, who owned his own roofing company. Every evening, he watched reruns of *The Rifleman, Gunsmoke, Perry Mason*, and *The Untouchables*.

"This is Tyrone Wilson. He works at the department."

Her father shook Tyrone's hand. "I used to hunt down south with a fella whose last name was Wilson. Yo folks don't come from the South, do they?" he asked.

"I don't know where my grandparents came from. I never met them, and I don't remember my mother ever saying. But I'm from Detroit." Tyrone smiled broadly.

"That's a rough town," her father said, shaking his head.

"Hey." Tyrone agreed by slapping hands with her father and brother on the matter. Sonnie's mother frowned at her husband, indicating that she did not approve of such ethnic gesturing.

"How long were you out in the sun this week?" Her mother leaned her head back and examined Sonnie's face.

"It's the color of that lavender dress she's wearing. Makes her look darker than she is," her sister-in-law piled on. Both women believed that dark-skinned people should never wear pastel colors. Sonnie's niece ran and jumped into her arms, wrapping her thin legs around Sonnie's hips.

"Look at your hair. Come here, girl," her sister-in-law exclaimed.

That morning, her sister-in-law had used two rubber bands to form a coiffed ponytail on either side of her daughter's head. Now those rubber bands were gone and spikes of hair jetted out comically from the sides of her head. Her sister-in-law's notions of what girls should look like came from *Girl's Life* magazines, which she found in the checkout aisle of her grocery store. The magazine rarely portrayed Black girls wearing French braids, dreadlocks, or cornrows, which would have held her niece's hair in place longer.

Sonnie lowered the girl to the ground. "I'll come get you on Saturday. We'll go pick grapes, and I'll show you how to make jelly, OK?" she whispered. The girl walked timidly to her mother, who grabbed her by the shoulder, swung her around, and began to French braid her hair.

"I don't know why this child's hair won't grow," she sighed.

"I just bought some ointment to put on it. So don't give up. We'll get some length out of that hair yet," Sonnie's mother told her daughter-in-law. Her mother's hair and sister-in-law's hair hung below their shoulder blades. The two believed that long hair was a demonstration of one's lineage.

Sonnie walked Tyrone to a Dairy Queen a block from the church. There, they both ordered chocolate ice cream cones and licked them as they walked through a nearby park.

"So why don't you attend church more regularly?" she asked.

"I do. I play ball every chance I get … The rules of the game are like your Ten Commandments," he responded.

"You're saying there's more than one way to respect the rights of others. I understand ... and I intend to join our local ethical society, a nondenominational place of worship where the parishioners believe you can lead an ethical life without believing in a god."

"Wow. What will your mother and father say about that decision?"

"That I'll go straight to hell." They both laughed as they reached the end of the park.

"Now what, friend?" he asked.

"I usually eat supper with my family on Sundays, so I need to drive you home," she replied. They returned to her car and drove to his apartment, where he thanked her and then disappeared down an apartment walkway.

He wasn't an educated man, but he wasn't a dummy either. His answers to her questions were clever, and he was a master in deceit. Given his guile, she had to avoid becoming his victim.

She had been overly trusting in college and had been easily deceived by the poet, and she did not want that to happen again. In the future she intended to be more cautious and shrewder.

But her eyes would have to see invisible things, and her ears would have to hear inaudible things, she thought.

Black, sooty powder covered the county repairman's hands, but his white shirt remained immaculate. He had found the problem with the copy machine and fixed it, but he still needed to reassemble it. Sonnie walked slowly back

to her desk and slumped in her seat, feeling completely frustrated by the machine that broke down weekly.

It was ten o'clock. She needed her report uploaded to the court computer by two, and that meant pleading with the clerk to get it there on time. The air conditioner wasn't operating. She began to fan herself, looking absentmindedly over a coworker's head and out a window at the overcast sky when her boss stepped up beside her. He was a short, balding, round-faced, and round-bellied man.

"Listen, my sister. This is Denice. Welcome her. Make her feel at home. Show her the ropes." He waved his hands with a peculiar pomp and formality.

A woman with shoulder-length, golden-brown hair; vanilla skin; even, ultra-white teeth; and hazel eyes stood beside him. Every hair on Sonnie's body raised, and she recoiled. The woman resembled the one who had married her poet lover in college.

Her boss bowed extravagantly and walked away, and the woman nodded hello.

"Do you call him Idi Amin for short?" Denice playfully nudged Sonnie's shoulder with her own. Their boss had an African accent and an authoritative way of speaking.

"I call him Judas Iscariot." Sonnie smiled slyly and playfully mimicked Denice's shoulder nudge. Sonnie explained the forms that were in each file cabinet and, pointing to the wall map, explained the zip codes workers in their office served. Then she introduced Denice to their court clerk and their receptionist and showed her where to obtain a parking pass. She didn't want to be prejudiced against Denice because of her looks. That was something

her mother did and she was trying to overcome her mother's influence.

After her orientation, Denice invited Sonnie to a party at her home the upcoming weekend, explaining that her brother, Howard, a deputy district attorney, was running for office and that the outcome of the race would become known the night of the party. She explained that her brother was running on a controversial defund the police platform and had previously run on a controversial marijuana legalization platform.

Sonnie had signed petitions for both referendums and was interested in meeting a candidate who might be able to implement such policy, so she accepted Denice's invitation. Then she began to attend to her own cases.

Denice sat reading her clients' folders and familiarizing herself with the abuse allegations against them. As coworkers passed by her desk, she looked them directly in the eyes. Her eyes sparkled and bounced happily as she chatted with them, and they seemed refreshed and restored by her lighthearted nature. Intrigued, Sonnie watched the magic Denice performed.

Tyrone and a coworker walked into the room. The two men spotted Denice and grinned at one another slyly before approaching her desk.

Like moths to a flame, she thought. *"Discipline,"* Sonnie whispered to herself.

As the two men approached her desk, Denice threw her head back and looked up at them, revealing her cream-colored neck and soft pink tongue.

She seemed gullible, even vulnerable. *Do such mannerisms indicate confidence or naivete?* Sonnie wondered.

"Hey," Denice said, smiling happily at the two men.

"How you doin'?" the men said in unison, looking from her to Sonnie.

Sonnie introduced the two men, who hopped and strutted like peacocks around Denice's desk.

"This can be a dangerous job, but if you ever need help, just call me," Tyrone said, handing Denice his county calling card.

"Be quiet and be still." Sonnie tried to suppress her jealousy.

On their way to an emergency home call, Sonnie and Denice passed a block-long swap meet; a discount furniture store; a brake, muffler, and transmission shop; and a free clinic. "Instant cash," one pawnshop window boasted. "Any kind of check cashing," another store window advertised. "The whole, true house of prayer," a third one informed the neighborhood.

The August heat made a colorful mirage in the middle of the street that hypnotized her. Distracted by the mirage, Sonnie at first didn't notice a man crossing the street with a grocery basket of yellow and flaking newspapers. She pounded her car horn and stomped her brake pedal.

The man's long, dry dreadlocks hung to his waist, and the soles of his feet were thick. He whispered to himself as he pushed his cart across the street and wandered into an area underneath an overpass. There he stood, arms crossed, talking to himself. Months earlier two children had been found where the man now stood.

"Why'd you leave your other job to work for county work?" Sonnie asked just to pass the time.

"I had an office with a view of a rose garden, one with music softly playing all day long, but I had no health insurance," Denice lamented.

"Came to get health insurance?" she asked.

"Yup," Denice replied. "My practice was in Crestwood Hills, a cooperative housing neighborhood where I grew up and still live. There's a neighborhood center there. My social work philosophy matched their cooperative housing ideas."

"Really? What type of ideas?" Sonnie asked.

"Well, I went to Immaculate Heart High School, a Catholic school in the Los Feliz area, you know. There they taught the concept of solidarity, which requires followers to treat everyone as brothers or sisters. And I learned the concept of distributism, which compels adherents to distribute their resources widely rather than concentrate them among the few." She continued. "At Catholic University, I wrote my senior thesis on Dorothy Day and the Catholic Worker Movement. Members of the movement believed in communitarianism versus individualism. My neighborhood board let me practice all these ideas."

"I covet the practice that you had. At Howard, I wrote my master's thesis on Jane Addams and her Hull House–type settlement. Addams's settlement idea is kind of a communitarian idea. But we leave Watts and South Central at the end of the day and go to middle-class homes and our clients know and resent this." Sonnie parked her car in front of a two-story apartment building.

An elderly woman who lived next door to one of Sonnie's clients had called her that morning to say that her

neighbor had not received her new medical insurance card and that therefore the local Walgreens' pharmacist refused to give her a psychiatric medication she needed. The elderly woman said she feared her neighbor was lapsing into one of her episodes and that she had taken her child into her apartment so that her neighbor wouldn't inadvertently harm her. Sonnie knocked on her client's door.

"Go away," her client shouted.

"It's me, Ms. Black," Sonnie yelled.

"Go away," the woman reiterated.

"I will, but I need to see you first."

A blackberry-colored woman in a matted wig unlocked the door, dentures in hand. Denice and Sonnie impulsively drew back.

"I'm going to get your medication," Sonnie assured the woman, and she and Denice backed away from the door and drove to the office computer room.

When Denice and Sonnie arrived at the office, the TANF workers were out to lunch. "Go and keep Judas busy," Sonnie told Denice, who turned and walked over to their supervisor's office, trying to think of a casework question to ask him.

"I'm sorry to bother you, sir, but I have a child—a teenager—on my caseload who's run away from her foster home. She's living with her mother's friend and refuses to be placed in a foster home. I cannot certify the mother's friend, because she whipped one of her own children, and we opened a case on her three years ago. What should I do?"

"Leave her where she is. Put out a warrant to cover yourself, the department, and the county." He was using a yellow marker to highlight his administrative directive. He didn't make eye contact.

"Thank you." She nodded.

Sonnie was right. He was a Judas. The warrant would protect her, him, the director, and the county, but it would do nothing to help the wayward and unruly teenager.

Denice knew that Sonnie did not have the authority to reauthorize expired Medicaid cards, but she typed away at the computer with sure, confident strokes. Denice assumed she seen the clerks do it hundreds of times and when she finished she held up the card as a signal to Denice.

The two scurried to the parking lot, drove to the neighborhood Walgreens client's pharmacy, obtained the prescription, and returned to the client's apartment. Sonnie gave her client the prescribed tablet along with a glass of water to help her swallow it. Obediently, the woman swallowed the pill and went to lie down.

Sonnie and Denice sat in the woman's living room watching Oprah until the woman awoke and seemed coherent. Sonnie prepared a bowl of oatmeal for the woman before she and Denice walked across the hall and knocked on the door. The neighbor's door opened. A girl dressed in pink shorts stood beside her.

"Can you make sure she takes a tablet each morning for a while?" Sonnie asked the neighbor.

"Not a problem."

"I'll be back tomorrow." Sonnie patted the neighbor's arm.

"This a new social worker?" the woman asked.

"Yes. This is Ms. Gray."

"Pretty girl, ain't she? A real honey-dripper." The neighbor woman continued to examine Denice's face and figure. Without responding to the neighbor's assessment of Denice, Sonnie turned her attention to her child client, who stood beside the neighbor.

Sonnie raised her hands, signaling that she wanted to play patty-cake. She and the child played several intricate clapping games, slapping one another's hands in elaborate ways, before Sonnie and Denice finally left and returned to the office.

"Let me be clear, Denice—if that mother hurts that child, it will be my fault and a result of my poor judgment. That's what our supervisor, the director, and the public would think," Sonnie said emphatically. Denice nodded her head slowly, accepting her new mentor's point of view as they turned into the office parking lot.

"I wonder if our copy machine is working today," Denice kidded.

"I wonder if our receptionist is sober today?" Sonnie tried to top her joke.

Chapter 3

Sonnie was startled when an older woman threw open the front door and stood wildly batting her eyes.

"Hi, I'm Sonnie," she stammered "I work with Denice ... She invited me."

The woman waved her hand for Sonnie to enter. She wore a grape-size diamond ring on her left middle finger. Her black eyes dramatically darted back and forth across her peach-colored face. Her white hair was swept up in a French roll at the back of her head, and she was as thin as a sparrow, which was obvious from the black leotard she wore underneath her orange paisley tunic.

"I'm Marium," the woman said, grabbing Sonnie's arm and gliding swiftly across the room. She theatrically bowed her head left and right, acknowledging her guests, before she abruptly stopped in the library of the house. The room contained hundreds of books, all bound in navy, maroon, and black leather and embossed with gold lettering. Sonnie wondered how long it had taken her hosts to acquire them and how much money they cost. A large oak desk sat in the

middle of the floor with a Tiffany lamp on top. A world globe stood in one corner, and a wire sculpture sat in another.

"Howard?" Marium interrupted her son who was in an animated debate with three other men. "One of Denice's friends from the county is here. Her name is Sonnie. Make her feel welcomed, won't you?" She leaned her head to the side as a curious bird would do.

A man with a massive blond afro, green eyes, and olive skin bowed and took her arm. A fine spray of sweat formed on her brow. Gobsmacked, her pupils dilated, her adrenaline surged, and she felt hot and cold in turns as if electricity were pulsing through her veins. She was unable to speak or move and was frozen in place, as she had been when she'd met the poet.

"Let me introduce you to my father," he said, ushering her across the room, seemingly unaware of his effect on her. "Dad, this is Sonnie. She works with Denice at the county." A tall, chestnut-colored man in a tan suit and black turtleneck sweater turned and bowed his head slightly.

"How do you do?" he asked, his head tilted backward as he appraised her high cheekbones.

"Offer Sonnie something to drink," he commanded. He continued his conversation with his guest and Howard obediently whisked her away.

"Let's see, there's beer, wine, bourbon, rum, tequila, and cognac. I prefer vodka. What would you like?" Howard asked.

"Just fruit juice for me." She tried to sound coherent but continued to wrestle with the riotous emotions he'd ignited.

"Fruit juice without rum? That means you haven't been to the islands yet, have you?"

"No, afraid I haven't traveled outside the States yet," she confessed.

"Me neither," said a mahogany-colored woman in a white apron as she entered the room. "I'm Bea."

The woman nodded at Sonnie and began to arrange hors d'oeuvres on a platter on the dining room table. Across the room a man frantically summoned Howard. He took a gulp of vodka, smiled, and excused himself. Relieved, Sonnie turned to Bea.

"I'm Sonnie." She bowed her head in deference to the older woman. Shorter than Sonnie, the woman tilted her head back and examined Sonnie's face.

"Pleased to meet you, Sonnie. Haven't seen you here before."

"Denice just started working for the county, where I also work, and she invited me."

"Uh-huh. Well, I've known Howard and Denice practically all their lives. He's smart and she's sweet." The woman offered Sonnie a sample of the hors d'oeuvres.

"Yes, but is he a gentleman?" Sonnie bit into the appetizer she held in her hand.

"You mean a Christian?"

"I suppose," Sonnie replied.

"Hm … I wouldn't say all that." The woman wiped her hands with her apron, bowed, and disappeared into the kitchen area.

Howard reappeared, took Sonnie's arm, and led her across the ranch-style house, zigzagging through the guests. She was surprised to see Romare Bearden's Two Women painting on the wall next to Monica Stewart's painting entitled *Flow*. He stopped at a bar area outside near the

swimming pool. She inquired as to how his family had purchased the paintings for their personal collection.

He explained that his mother was on the board of curators at the Afro-American Museum and thereby had connections with many artists who had installations there. He put down his empty glass, found a clean one and poured himself another vodka. Will Downing's singing The Warmth of You came on the pool speakers.

You are so exotic.
What you do is so hypnotic.

"Wanna Dance"? he asked. He held out his hand. Her pupils dilated and she hesitated before taking his hand. He looked down at her and his arm tightened around her waist. Intoxicated by the smell of his *Obsession* aftershave she lay her head on his chest and was about to exhale when a vanilla-colored woman with green eyes sauntered up to them.

"Will you take me home tonight?" the woman asked slipping her arm underneath his.

"Sorry, I'm busy hosting tonight," he said, facing her but looking over her shoulder, not at her face. The woman looked at Sonnie and back at him before she excused herself and walked away.

"Do you always turn down such gorgeous women?" Sonnie asked.

"Let's just say liberated women annoy me." He took another gulp of the vodka he had poured for himself.

"Oh, there's Denice." Sonnie waved at her, and Denice returned her wave from the other side of the pool.

"She's been upstairs. Couldn't decide what to wear." He rolled his eyes.

"I'm gonna go say hello." She nodded as she excused herself and walked toward Denice.

"I've been upstairs trying to get my bosoms into this sundress." She winked tugging gently at the bodice of her Carlie Cushnie form fitting dress.

"Who's the woman over there with the green eyes?" Sonnie asked.

"Oh, that's Serena. She works in the DA's office. Her father owns a barbecue chain, and she lives down the street. We all grew up together. Wants to marry Howard." Sonnie raised her eyebrows, and Denice mimicked her gesture. "He likes her about as much as I like that guy over there." Denice nodded toward a man who wore round, wire-rimmed glasses and who, except for his sienna-colored skin, reminded Sonnie of Santa Claus.

"Sexy, huh?" Denice elbowed Sonnie sarcastically. "His name is James St. Clair. He's my father's choice for me. Junior pastor of the 10,000 seat Prosperity Gospel Center here. Watch this," she quipped. She sauntered over to a man who stood on the other side of the pool and slid her arm around his. He looked down at her lasciviously. She glanced over her shoulder and comically winked at Sonnie. Sonnie shook her head. *Such a comedian,* she thought.

An American actor of Nigerian descent who was performing the title role in the play *Hamilton* introduced himself as Marium's friend, and he introduced her to a jazz vocalist who was performing at the Kennedy Center the next night. Her husband was an architect on the design team building the National Museum of African American

History and Culture, and she introduced Sonnie to a woman who had created *The Quiet Storm* on Howard University's radio station and now owned a TV station. She confided she knew a member of the city council who had told her most members of the city council were not in favor of the defund the police policy. All agreed her revelation did not bode well for Howard.

At ten o'clock, folks gathered around the big-screen TV that covered a wall in the living room to hear whether Howard had won the DA race, and the group grumbled ominously when the TV announcer said he had not. Denice and the caterer began to clean up as people said good night, and Howard, vodka glass in hand at the front door, thanked his guests for coming; each one bemoaned his loss and assured him he would win next time.

"Let me walk you out," he offered as Sonnie approached the front door, and he walked her across the street to her car. She pressed her key fob and unlocked her doors.

"Do you mind if we talk for a minute?" he asked. She was surprised by his request, but she let him in her car. Once inside, neither spoke. The numbers on the digital clock changed. Still, Howard said nothing.

"I'm sorry you didn't win the election." He said nothing. "I supported the marijuana legalization referendum, and I support the defund the police legislation too," she added. He stared at the windshield. "The city council is worthless." This was going to be her last attempt to get him to talk.

Slowly, he leaned toward her and began to gently plant warm and moist kisses on her eyelids, cheeks, and mouth. Thirstily, she drank in his kisses, lost in an ocean of emotion before the sharp smell of vodka alarmed her.

She grabbed his wrist, but he easily withdrew from her grip and tried to subdue her, but his arm hit the car horn, sending a loud blast into the night. The two scuffled before the passenger door flew open, and Denice and James stood looking at them. Howard settled himself in the passenger seat and straightened his tie.

"Forgive me, Sonnie. I have been drinking all evening. I was disappointed and ashamed I did not win the DA race, and things are not going well between me and Serena. I apologize for my behavior." Clearly embarrassed, he looked at the windshield as he spoke. Denice and James continued to stare at him. Disheveled, Sonnie said nothing. He opened the door, stepped out, walked across the street, bounded three stairs, and walked past his father, who stood in the doorway.

"Are you OK?" Denice asked.

"Yes." Sonnie straightened her dress, started her car engine, and drove away.

Arriving in front of her apartment, she turned off the engine but remained in her car looking out her windshield.

"Silly woman," she said aloud, pounding her fists against the steering wheel. Tears streamed down her face, and her throat ached. She opened her mouth wide, and a growl pierced the darkness.

Who could be trusted, and how could she tell?

Denice had accompanied Sonnie on home calls the previous week, but this was her first solo visit, and she discovered she had the wrong client. She pulled over to

park near a small grocery store to call the county clerk to get the correct address.

A sign on the window in front of the store advertised "scratch-and-win lotto," indicating that lottery tickets were sold there. She stepped inside. The three-aisled store was dark, there was sawdust on the floor, and she could hear the rotation of the laundromat dryers next door. A square-faced Korean man sat smoking a pipe, and a Korean woman in a mismatched flowered blouse and plaid skirt sat beside him eating rice from a bowl with chopsticks. The smell of garlic pervaded the store.

"Can I stand inside so I can get a phone signal?" Denice asked.

"Buy something or go," the man said, waving his hands for her to go away. Denice was incredulous and didn't move.

"Buy something or go," the Korean woman beside him repeated angrily.

"I see." Denice turned to go.

"Black not white or Mexican girl," the woman told the man.

She had tried the address ending in "street," so she decided to try the address ending in "drive." She parked and walked up a set of stairs. An ebony-colored man with his two front teeth missing and a black scarf tied around his head nodded at her. She returned his nod and knocked briskly on the door, which suddenly flew open. The smell of mold accosted her nose.

"Hi, I'm Miss Gray, your new social worker." Denice wiggled her nose.

"Come in," a short, round woman with bulging eyes blurted.

Denice gingerly stepped in, surveying the room. Dingy white sheets covered the two front windows, and holes in a murky gray rug revealed the concrete beneath. The woman sat on one side of a small, square card table. Denice sat on the other.

"I'm your new caseworker," Denice said, smiling at the woman. "So I just wanted to introduce myself to you and your daughter."

The woman picked her teeth with a frayed toothpick. Her hair was about two inches long and stood out from her head in spikes. A five-year-old girl dressed only in her panties ran in and stood, inhaling Denice's Oscar de la Renta perfume.

"How you doin' today?" Denice asked the girl, who did not reply. "Can I just take a quick look around?"

"Go ahead," the woman responded.

Denice walked into the woman's dimly lit kitchen. Two roaches crawled in and out of a box of oatmeal. She backed out of the room and crossed to an adjacent room. As she entered, she felt a floorboard give under her weight. She looked down and saw a gaping hole underneath the floorboard. She was afraid to continue farther, so she returned to the table. She could write the woman up for unsanitary and hazardous living conditions, but she chose to ignore the roaches and the hole in the floor.

"Have you been going to sign language classes?" Denice asked.

"No, it's too far, and it's offered at night," the woman replied sharply.

"But it would help if you would communicate with your daughter … and it might prevent her from being sexually molested again."

"Maybe. But as I said, it's too far away, and I don't have a way to get there and back at night."

"You know, if I feel your daughter is in danger of being sexually assaulted again, I am mandated to remove her from your home. I feel your inability to communicate with her puts her at risk of harm in many ways."

The woman stood up abruptly, knocking her chair over.

"Listen, Ms. Ann. Neither you nor nobody else gonna take my daughter away from me. Who do you think you is anyway? Comin' in here. Snoopin' all around. Must think you white. Well, Miss, let me tell you something. You gon be black all yo life. Now, you just get yo ass out of here."

She grabbed Denice by the arm, ushered her to the door, and shoved her toward the concrete stairs. Denice's heels wobbled beneath her as she stumbled down the stairs and slid across the concrete. She looked back at the woman, who held up a fist and shook it menacingly before slamming the door. Jumping up and down, the man wearing the black scarf slapped his leg in laughter.

Denice stood up. Her stockings felt like spiderwebs around her knees. She picked up her briefcase, unlocked her car door, and got in. She looked at her itinerary and saw that she had two more home calls to do. She looked at her face in the rearview mirror. Tears ran down her cheeks. She dabbed her face with a tissue, started her engine, and drove to her next home visit. Her second client was not home, and she merely inspected her third client's home for safety before she left Watts and took the 110 to the 405 headed for home.

It took her an hour to get to the driveway of her home in Crestwood Heights and she entered a side door and climbed the stairs to her mother's bedroom. Her mother sat in a leather chair, a glass of wine in her hand, watching Judith Jamison perform "Cry" on PBS. Denice sat down next to her. The two of them had watched Jamison perform this ballet many times. It was the way her mother reminisced about her career as a choreographer.

"How'd your home calls go?" her mother asked. Denice groaned.

"I was thinking you ought to buy yourself some plastic gloves. People like your clients have all kinds of contagious diseases—ringworm, lice. Try to wash your hands when you leave their houses, and don't eat or drink anything they give you, not even water. If anybody's sick in the house, don't even go in."

"I'm gonna take a bath." Denice patted her mother's shoulder and walked across the hall to her bedroom with an adjoining bath.

Once the bathtub was full of hot water, she slid in, listening to Nina Simone sing "Four Women."

> My skin is yellow
> My hair is long
> Between two worlds
> I do belong

Her bath water turned cold. She stepped out, wrapped a king-size towel around her, and ambled to her canopied bed. She lay on a cream-colored blanket, inhaling the smell of fabric softener. She heard her father come in the front

door and go into her brother's childhood bedroom, where he slept every night.

She thought about the earlier home visit to see the deaf child. The incident frightened her. She wasn't as tough, brave, or experienced as Sonnie. She didn't slip in and out of dialect as easily as Sonnie did. She had never been in a fight with another person before, and she didn't want to be in one again. She needed to be protected. Tyrone had offered to help her if she needed it, and now she did.

She opened her wallet, took out his county calling card, and dialed his number.

Tyrone decided that Denice was like the cheerleaders he had dated in college. They all had the same length of hair, complexion, and diction. Tonight, men would envy him and think he was rich because he was with Denice. He straightened his shoulders and dared men to look him in the eyes. This was the man he was supposed to be. A proud man with proof of his abilities on his arm. He was happy.

He took her to a place to dance in Century City, and he paid to park his car and paid for the cover charge for them to enter. She wore a white dress with no bra. She knew the latest dance steps and danced provocatively, her nipples brushing against his chest.

She was a tease, but he knew how to handle a tease, especially one who didn't have enough sense to bring a friend to cockblock. He paid for a second and third round of drinks. When they left, she wasn't drunk, but she had

loosened up enough that she agreed to go to his apartment for a nightcap.

He poured her a glass of white wine when they arrived at his apartment and dropped one ketamine pill into it. He reached for her hand and pulled her to him, and they began to dance to "The Girl from Ipanema" by Astrud Gilberto, João Gilberto, and Stan Getz.

> Tall and tan and young and lovely
> The girl from Ipanema goes walking
> And when she passes
> Each one she passes goes "ah!"

By the end of the song, she was drowsy and headed for his couch but collapsed before she reached it. Her lifted her in his arms, carried her across the room, and laid her on the couch. He stood over her, waited a moment, and called her name. She didn't answer. She was unconscious.

He lifted her dress over her head, exposing her perfectly round breast. He arranged one of her arms over her head and put her hand in her vagina. He stepped back, reached for his phone, and took a picture of her before repositioning her body again and again. She mumbled something he didn't understand.

"Denice," he said, but she did not respond. He stood, looking at her lovely face, and unzipped his pants. When she woke hours later, she said nothing to indicate that she knew what he had done. He walked her to her car, and she drove herself home.

Chapter 4

Tyrone sat in his living room, smoking a joint. Twice since the incident at the deaf child's home, Denice had asked him to accompany her on a home call. She owed him, and it was time to collect. He dialed her cell phone number.

"I thought you might want to come over and shoot pool in my apartment's rec room."

"Um, I don't think so. I brought a lot of casework home with me tonight," she said.

"Well, I have a present for you," he coaxed.

"A present?" She was curious.

"Yeah," he said.

"Well, I guess I could stop by for a minute. I'll see you in half an hour."

"Half an hour," he repeated.

When Denice arrived, Tyrone was playing the O'Jays song "For the Love of Money" loudly, and she had to knock more than once before he opened the door. The title of the

song came from Timothy 6:10 in the Bible: "For the love of money is the root of all evil: which while some coveted after, they have erred from the faith, and pierced themselves through with many sorrows."

Knowing this scripture well, she declined the wine he offered. He began to show her a photo album, pictures of him playing basketball at college, newspaper clippings of his skill at shooting and dunking the ball, and photos of him with cheerleaders.

"I thought you said you had a present for me?" she asked.

"Can't wait, hmm?"

"It's just that I need to write some court reports tonight. That's all."

"Well, the reason I asked you to come over tonight is that I want to start a basketball recruiting business. You know, fly around the country, recruiting athletes from high school for college. But I need someone with people skills to help me," he explained.

"Hmm."

"And I thought you might be willing to help me."

"Help? In what way?"

"Telephoning and scheduling. That sort of thing. I wouldn't be able to pay you at first but …"

"I'd like to help you, but I can barely do my county job."

"Does that mean you won't help me?"

"It means I might be able to help you now and then, but as I said, I just don't have the time."

"I see," he said. He crossed the room, picked up an envelope with a red ribbon, and handed it to her.

She pulled the ribbon and opened the envelope to find a set of photographs. She lifted them out and looked at them, seeing pictures of herself in lewd poses.

"Think about my offer. Perhaps you will change your mind," he said as he opened his living room door. She stepped out, refusing to look at him. She ran down the stairwell, through the pool area, and out to her car. Once inside her car, tears filled her eyes. The danger she felt while doing home calls had compromised her judgment.

She didn't use birth control pills, because she had never had sex with a man before. What if she was pregnant? What if she needed an abortion? She needed to see a doctor right away but certainly not her family doctor. She needed advice, so she headed for Howard's place. He would know what to do. He would know if legal action could be taken against Tyrone. He would defend her honor or see that someone in the DA's office did. If her assault became common knowledge, it could jeopardize her chances of marrying James St. Clair. He was an honorable, respected man, so he must never know, never.

Denice and Howard had gone to see a gynecologist in the Valley that morning, and she had requested a morning-after pill. The pill would prevent her from becoming pregnant, a pregnancy that she was sure would ruin her life. She was pretty sure this meant she was excommunicated from the Catholic Church but was afraid to ask her priest.

When she arrived late to the office, two police officers waited for her in the guards' area, and they handed her a

three-year-old Hispanic urchin. She had arranged for him and his mother to live in a group home for teenage mothers in Hollywood the week before. Staff from the home had called an ambulance to take his mother to the hospital that morning, and she had been diagnosed with pneumonia and would have to remain there for days, if not weeks.

Denice was talking to a client on the phone while the toddler with long, wet eyelashes sat on a small stool next to her. Looking anxiously around the busy and unfamiliar room, he sniffled and moaned. Sonnie tried to help by consulting the foster care computer to determine if any foster parent had an opening and found one in Pasadena. She handed the address to Denice and bent down to soothe the child but immediately recoiled.

"Don't place him in foster care," Sonnie said as she walked by her desk. "Take him to the infirmary. He has impetigo."

Denice's cheeks began to itch. She imagined her blemish-free complexion scarred by impetigo sores but overcame her fear and wrapped the child in a county blanket from the storage room before driving him to a county facility that housed sick children who were under county supervision.

When she returned to the office, Sonnie handed her a bottle of bleach to clean the stool the child had previously sat on. She cleaned the stool, her desk, and her phone. Then she pretended she was going to wash the wall near her desk. When Sonnie laughed, she got down on her knees and pretended to scrub the floor. Such a comic, Sonnie thought.

She was pretending to scrub the floor around her desk when Tyrone walked in. Her smile faded, her eyes watered, and her bottom lip trembled. She ceased her antics, sank

into her seat, and began to draft a report telling the court the toddler had been placed in the county infirmary. Upon completing the report, she walked it over to the court clerk's desk.

"Would you put my report on tomorrow's court docket?" she asked.

"Out of luck. I got too much work to do the court clerk said," and she signed out of her computer and walked toward the door.

When the clerk was gone, Sonnie came over, typed in the clerk's password, and downloaded Denice's report to the court docket for the next day. Denice knew Sonnie could be fired for doing this. She threw up her hands, walked to her car, and drove away. She still wanted to help children and the poor, but she no longer wanted to be a child welfare social worker.

She called James on her cell phone and asked if he wanted to come over for supper that evening. She said her father would be home and the three of them should have a talk about the future. She didn't love him and was repulsed by his ruby-colored swollen lips and sweaty palms. But marrying her was something he had wanted to do since high school, and that would make him happy.

James was late for the church advisory board meeting, and when he entered, a man with red hair and white knuckles was shutting down his PowerPoint presentation. The man had been trying to sell equipment to his father for the new church recreation center add-on. He looked at his mother, a

cinnamon-colored woman whose resounding singing voice reminded him of Mahalia Jackson, lowered her eyes as if she wasn't buying what the man had to sell.

His father no longer knew the name of every child in the congregation and could no longer hug everyone on Sunday morning. Their congregation no longer consisted of trash collectors, janitors, and auto mechanics. Now it consisted of doctors, dentists, and city councilmen who primarily came to network with one another after service.

After the meeting, James's father invited Howard and Serena for supper. After arriving at their Baldwin Hills home, James helped his mother in the kitchen while his father poured Howard a glass of vodka and Serena stood in the foyer, patting her face with a powder puff.

His mother had given the housekeeper instructions for what to prepare that evening. Now all she had to do was serve it, but she moved like a sloth to avoid becoming light-headed due to her high blood pressure condition.

"Seems like Howard's gon marry Serena," James's mother said. "They're always together these days." She looked at James.

"I guess," he responded. "I don't try to keep up with their business, but they certainly deserve one another." He grinned sinfully at his mother, and they carried the roast and potatoes into the dining room. Howard and Serena sat on one side of the table, he and his mother sat on the other side, and his father sat at the head.

"Did you see that redheaded guy?" Serena asked. "Kept scratching his head. Musta had dandruff."

His mother's brow wrinkled in disapproval, as did his and his father's.

"The focus of the church's fitness center shouldn't be on weightlifting, a type of idolatry. The focus should be on health and nutrition," James proposed.

"Hmm." His father considered his proposal.

"Weightlifting machines will entice men to come to our church," Howard argued.

"But we have twice as many women as men in the congregation." James tried to reason with Howard.

"Yoga and dance classes will not pay what it costs to build the center," Howard contended.

"The center was never intended to be a commercial gym," James maintained.

"Ahem." His father cleared his throat, signaling for the two men to stop arguing.

"Our congregation suffers from obesity and diabetes," James persisted. "So, nutrition should be the focus of the church center."

"Oh, for God's sake," Howard protested. "Next, you'll want us to hire the homeless to take care of the church grounds. What's with you?"

"Ugh! Homeless folks are full of lice," Serena said. Everyone at the table frowned at her for her flagrant lack of empathy.

"What? I'm only telling the truth." she said without shame.

"Man, you're not talking good business sense." Howard held his hand up to emphasize his point.

"This is not a business," James said. "You keep forgetting." He stood his ground.

"Well, I think we've had a lively discussion this evening." James's father stood up. "But now, I need to go and answer parishioner emails. In other words, duty calls."

"Good evening, Reverend St. Clair." Howard and Serena stood as their pastor walked away.

"Man, you got to be left-brained about this." Howard tried once more to convince him. "James, I'm so tired. Help me clear the dishes," his mother said. Howard and Serena understood it was time to go. James walked them to the door and then returned to the table and helped his mother clear their dishes.

"I swear, I can't see what she sees in him," he said, placing the dishes in the dishwasher. "Or him in her."

"Does Denice want to be married in your father's church?" his mother asked.

"I'm sure."

"And do you want your father to invite the mayor and the city council?"

"Yes, Lord. I want everyone to know I'm marrying Denice at long last." He grinned.

He hugged his mother and walked her to her bedroom before peeking into his father's den. His father looked up from his Bible. His face was weary, yet serene. Enumerable female parishioners had chased after his father over the years, but as far as James knew, he had remained faithful to his mother. Abstinence gave his father as much pleasure as indulgence would have.

"What did you think of my ideas?" James asked sheepishly.

"They're good ideas," his father replied, taking off his glasses and wiping his eyes with his handkerchief.

"But?" James asked. His father cleaned his glasses.

"In checking my email, I noted that the Interfaith Network, an alliance of fifty churches, has decided to build low-income apartments on the land surrounding each church. I want you to lead this project for our church. It's a special ministry and if fruitful, could become a legacy for your son."

"It never occurred to me that I could have a legacy other than my ministry to leave a son. I'm so happy that you trust me with such a worthwhile project."

"I remind you that Matthew 7:16 states, 'by their fruit you shall know them.'" His father smiled lovingly at him.

"Yes, sir," he acknowledged. He was about to say goodnight and leave, but his father held a finger in the air.

"And one last thing son. I want you to share this venture with your future brother-in-law, Howard. It's true he's deputy district attorney and therefore a part of the state, but don't think of him as Pontius Pilate. Think of him as Constantine, who helped spread Christianity."

"Of course. I'll speak to him about the project at service this coming Sunday." James patted his father's shoulder and headed for his bedroom. He didn't like Howard. He was conceited and arrogant. Proverbs 16:18 stated, "Pride goeth before destruction," and thus he did not want his fate tied to Howard's. But like it or not, Howard was now his cross to bear.

He walked to a casita behind the family house, turned on a wall-size TV, searched for YouTube, and then searched for a song by gospel singer Donnie McClurkin. A piano concerto began the song before McClurkin's tenor voice chimed in.

We fall down.
But we get up.
For a saint
Is just a sinner who fell down
And got up.

The song, his favorite, lifted his spirit. He took a shower before getting into bed, where he thought about Denice— her vanilla skin, her silky brown hair, the delicate shape of her nose, and her tulip-shaped lips. He thought about how men would envy him and how proud he would feel whenever he entered a room with her on his arm. He sighed, fell asleep, and dreamed of her.

Chapter 5

Inside, their apartment building was as cool and dark as a cavern. As Frankie and Lisa climbed the stairs to the second floor, the smell of Pine-Sol assaulted his nose. Frankie Jr. slept in Lisa's arms. Frankie thought back to when Lisa had brushed against him in this same building years earlier.

Startled, she had placed her hand on her breast, causing him to note their size and shape. She'd lowered her eyes demurely, touched his arm, and asked if he was all right. He'd been immediately taken with her and had followed her and waited for her outside of her part-time job at Church's Chicken, to give her a ride home from work.

She had accepted the rides but refused to go on a date with him. He'd continued to coax her, giving her first a diamond ring, then a leather coat. She accepted the gifts but remained aloof until her mother died and she became her younger brother's caregiver.

"Good morning, Mr. Charlie." Lisa walked up to the old man and kissed him on the cheek.

"Hi. How you doin', child?" Mr. Charlie replied, his voice quivering from his perpetual cigarette smoking.

"I'm fine, Mr. Charlie. And you?"

"Ah, my sinuses is acting up."

"Ah," Lisa responded sympathetically.

Frankie walked over and shook the man's hand. "How's it going, Mr. Charlie?" he asked respectfully.

"If I had yo hand, I'd throw mine away." The two men chuckled.

"I'm gonna be down the hall a minute," Frankie told Lisa, and he continued to the next apartment and knocked on the door.

"Come in," a woman yelled.

He opened the door and stepped in. His neighbor sat at a kitchen table, picking green beans and watching TV in her housedress. A cigarette with a long trail of ash hung out of her mouth. Frankie walked over and kissed her on the cheek.

"What you say, Frankie?" the woman asked without removing the cigarette.

"I'm all right. And you?"

"My arthritis is kinda actin' up." She shrugged.

"What can I get you?"

"Ah, I got some ibuprofen, and I got some gin if that don't work."

"I heard that," he said as he followed her teenage son into a bedroom and closed the door.

"Man, look at this," the teenager said. He opened a trunk and took out a Playboy magazine. He pointed to a woman in the centerfold. "She got tits and ass. She's perfect.

I want my woman to look just like that." He raised his hand to slap Frankie's.

"That type of woman is as cold as the ocean or the moon." Frankie shrugged.

"Man, you don't know what you talkin' 'bout."

"White women are like clouds. Like shadows. You can see them, but you can't touch them. That's why I'm with Lisa. She's solid."

"Man, Lisa can't hold a candle to this girl."

"That's what you think now, but you wait," Frankie cautioned.

The boy put the magazine back in the trunk and began to lift stacks of twenty-dollar bills and place them into Frankie's backpack.

"Remember, it's just you and the Colombian from now on. I am no longer involved, and he will contact you directly. I'm goin' legit, starting a business on the west side."

The teenager nodded and opened the door to the room where the woman was now washing green beans in the kitchen sink. There was noise in the hallway, and the teenager opened the apartment door. Lisa wrestled with Frankie Jr., who squealed, trying to get away from her.

"I told you not to let him come down here," Frankie said, lifting Frankie Jr.

"Ahem." Sonnie cleared her throat from behind Lisa, and Lisa turned around, surprised to see her.

"How you doin', Miss Black?" Lisa whispered.

"Good," Sonnie replied, turning to accompany them down the hall to Lisa's aunt's apartment.

The kitchen cabinets had at least ten coats of paint on them, the latest one pea green. All but one of the knobs on

the stove were missing. The remaining knob was moved from burner to burner, depending on which one was being used. The refrigerator leaked water on the floor, creating a puddle, which was continuously mopped up. The metal pins that held one leg of the kitchen table had become permanently detached. If someone accidentally hit that leg, it would fall over and the table would lean, spilling its contents on the floor.

The bathroom was the size of a small closet, and the lever to the toilet was no longer attached to the chain. Instead, the porcelain top of the toilet was on the floor, so the chain could be pulled manually. Lisa, her aunt, and Frankie Jr. slept in the one bedroom, and Frankie and Lisa's brother slept in the living room on a Murphy bed.

Frankie sat on the couch, holding Frankie Jr., and Lisa stood in the middle of the floor. Her aunt continued picking brown beans at the table. There was a knock on the door, and the woman from next door peeked in.

"Is everything all right?" she asked.

"Fine. Come on in," Lisa's aunt replied.

"Ms. Sarah, this is my social worker, Ms. Black." Lisa introduced her neighbor.

"How you doin', sweetheart?" Ms. Sarah asked. "I got a child welfare worker. Her name is Miss Lennox. She ain't been out here but once in six months. Guess she's afraid somebody will steal her BMW. You know Miss Lennox?"

"Yes, she works in my office," Sonnie said.

"Told me she had eighty county kids she's supposed to see each month. How many kids you gotta see?" she asked.

"About the same," Sonnie said.

"County workers oughta stay outa grown folks' business—wouldn't have such a high caseload." She grinned at Lisa's aunt. "County accused me of whipping my child. He stole something. How else am I gonna punish him? They told me to go to parenting classes, but there are never any openings." She turned back to Lisa's aunt. "I came to get some of your salt pork."

"Go cut yaself some," her aunt replied.

"Lisa, cut me a piece."

"Yes, ma'am," Lisa quickly complied with her neighbors request.

"Come here and give auntie some sugar," Ms. Sarah said to Frankie Jr. He waddled over to her, and she picked him up and planted a wet kiss on his cheek.

"I received a flyer today. UCLA needs unit clerks. After you go through training, you begin work." Sonnie handed Lisa the flyer.

Frankie leaped from the couch and snatched the flyer. "You've seen my son. He's fine, and Lisa don't need a job. She has one: taking care of Frankie Jr." He didn't want Lisa to go to work. If she did, he feared she would become a bureaucrat, and bureaucrats, like Sonnie, had no feelings. Or if they did, they felt "duty" or "responsibility." Nothing more. They were zombies, robots, technicians. Sonnie looked at Lisa, who lowered her eyes. So did her aunt and Ms. Sarah.

"I'll see you in a few weeks," Sonnie said to Lisa. "Call me if you need me."

After arriving at home, Sonnie pulled a plastic bag of crab legs out of her refrigerator. She threw them in a pot of boiling water and chopped and mixed spinach, onion, and tomatoes to make a salad. She stared at Monica Stewart's *Rejoice* print on her living room wall.

She felt restless and paced back and forth. Frankie was right. Women needed to stay at home and guide and nurture children. Innumerable studies had proven that to be true. But at the same time families couldn't live on one income. Mothers had to at least supplement fathers' incomes and that meant they had to have a skill. She could not decide if she was doing the right thing by encouraging Lisa to abandon her toddler for the workplace. She shook her head vigorously, trying to clear her mind and her mind wandered to thoughts of Howard. He only wanted her sexually, and that made her feel bad about herself, as if she was less than the green-eyed Serena was.

She turned on the TV, searched for YouTube and then for Jennifer Holliday's rendition of "And I Am Telling You I'm Not Going" from the Broadway musical *Dreamgirls*. Between David Foster's orchestral arrangement and Jennifer's defiant performance, the song always uplifted her.

> You're the best man I'll ever know.
> There's no way I could ever, ever go.
> No, no, no, no way
> No, no, no, no way I'm living without you.

The August sun hadn't reached its apex, so the eighty-degree weather was more tolerable than it would be later in

the day. Palm trees surrounded the park in West LA, but pine trees inhabited it. The smell of jasmine mischievously skipped through them. Victorian houses with six bedrooms, pillared porches, and manicured lawns stood stoically in the background. In the middle of the park, men and boys with tiny, circular black hats on their heads guided miniature boats around the side of a pond.

Although Lisa believed their hats indicated their religious membership, she wasn't sure which religion or how it differed from Christianity. She sat on the bench, watching Frankie Jr. waddle after a ball in his miniature, blue overalls and red tennis shoes. Each time he came near the ball and tried to pick it up, he kicked it even farther with his tiny feet, causing him to giggle.

She picked him up and hugged him to her full breast. Then she put him and his ball into his wagon and crossed the street. They passed by a delicatessen, a fruit and newspaper stand, and a flower shop. All were owned by people with olive skin, black hair, and accents. She turned off Pico, onto the block where she lived. Pulling the toy wagon past the houses, she admired her neighbors' plants but regretted not knowing the names. Lisa decided that instead of getting literature from the library, she would get books on plants and trees instead.

She had never given Sonnie this address. Instead, they had pretended to live in her aunt's apartment. If Sonnie knew where they lived, she would wonder how they could afford such an address.

The hum of the aquarium filter settled Lisa as she entered her front door and glanced around her living room. A long, tan leather couch sat in the middle of the floor,

and a matching chair stood to one side. A seven-foot-long aquarium sat against one wall. A three-paneled picture hung on the other. To one side of the picture sat a six-foot potted palm. She laid Frankie Jr. in his playpen for a nap. He held up a twig.

"See?" he said. She smiled at him and gently took the twig from his hand. He lay down again and rubbed his eyes, staring drowsily up at her.

She looked out her living room window. Seventy-foot palm trees spaced forty feet apart lined the street in either direction as far as she could see. Across the street, her neighbor's yard contained miniature Bonsai trees and a rock garden. It was quiet, and except for a jogger, the street was deserted.

She had mowed the lawn that morning, and the lawn mower remained outside. She went outside to put it away. The day before, she had cleaned the aquarium and washed the car. Tomorrow, she intended to clean the stove and the refrigerator. Having stored the lawn mower in the garage, she went to the laundry room to get the clothes and a wicker hamper. She sat on the couch, sorting their dirty clothes.

As she separated the dark clothes from the light ones, she heard Frankie entering through a side door. He walked to the refrigerator, poured himself a glass of lemonade, and drank it down before he ambled over to lay in her lap. He pulled down on her blouse and bra at the same time, exposing a brown nipple. He put his mouth on it and sucked. She held his head as if she were nursing him. He sighed, and she rocked him until he closed his eyes and fell asleep. She kissed his cheek and repositioned him on the

couch before walking to Frankie Jr.'s playpen, where she repositioned him.

She tiptoed upstairs. The heat from the noon sun made her bedroom feel like a cocoon. She thought about what Sonnie had said—that she needed a skill. Eyeing herself in the mirror, she unhooked the post from four of her six stud earrings and took them off. She left one earring in each ear as she went to her dressing table. She began to unbraid her hair. The extensions fell around her feet. She poured a solution and began to take her blue nails off. She was a butterfly emerging from a cocoon.

The heat of the day gave way to a multitude of stars that sparkled as if the sun had burst into thousands of tiny pieces. Frankie threw his head back and looked up at the sky for any answers that might fall from it. The combined smell of the earth and orange trees enchanted him, and he sighed. The warm summer breeze encircled, seduced, and intoxicated him.

A Colombian immigrant in a white suit and a two-hundred-dollar Beverly Hills haircut sat in a lawn chair next to Frankie, twisting a Rubik's Cube. They'd met at a Beverly Hills car dealership where Frankie repaired car seat leather. He had repaired the Colombian's vintage Jaguar car seats.

The Colombian had been with him the day his son had overdosed. That day the Colombian had visited Frankie at his home in West LA while Lisa visited her aunt in Watts. Frankie Jr. had been napping on a blanket on the floor.

Frankie and the Colombian had gone into the kitchen to get some baking soda and a spoon to cut some cocaine they intended to sell that evening. When they returned, Frankie Jr. was awake. The child was licking his tiny hands, which he had put into the pile of cocaine. He had smiled, showing his baby teeth, before falling backward, jerking sporadically, and turning a cherry color.

Frankie and the Colombian had rushed him to the hospital, but he'd stopped breathing by the time they had reached the emergency room. Frankie Jr. was in a coma for forty-eight hours, and the hospital had notified Children and Family Services. The Colombian told the hospital social workers that he was a stranger to Frankie but had seen the baby pick up a substance off the ground and put it in his mouth. Because the child almost died, a case was opened with Children's Services.

Frankie intended this to be the last time the two met one another. The Colombian rose and opened the door to the warehouse and turned on the lights. Frankie walked in, shifting a toothpick in his mouth before pulling his backpack off and withdrawing $500,000. He sat the money on an unvarnished table. The Colombian counted $250,000 and put it in his briefcase before handing $250,000 to Frankie.

"So, I guess I'll be working with the teenager from now on, instead of you?" the Colombian asked.

"Right." Frankie grinned, shifting the toothpick in his mouth. He felt free of the burden he'd carried for two years while selling drugs. The next day, he would deposit his cut of the money in his bank as part of his new upholstery business account. The Colombian closed and locked the warehouse door.

"Well, I hope he will be as profitable a partner as you have been. *Vaya con Dios*, my friend." The Colombian slapped Frankie's hand, hugged him warmly, walked to his Jaguar, and drove away.

Frankie inhaled the warm night air and then exhaled, releasing the heavy burden of handling cocaine. A new life awaited him. He was crossing a field to his car when he heard a sound. It stopped when he stopped and started again when he did. He drew a gun from his jacket pocket and fell to the ground. He heard footsteps scurrying in the bush. He lay still, his heart pounding before he gained the courage to run.

"Stop! Police," a voice commanded.

Frankie fell to the ground again. Goosebumps rose on his skin, and a violent shiver rocketed through him. If God would only let him return home from this last deal, he could create his own leather upholstery business.

Using his elbows, he lifted himself as if he were doing pushups and ran for his car. Out of the corner of his eye, he saw a gun coming through the window. He stomped the gas pedal to the floor. The car lunged forward just as he heard a loud gun blast. He swerved the car across the field for miles before he pulled over. Not hurt or bleeding, he looked out of the passenger window. The glass was missing. The gunshot had completely shattered it and the driver-side window.

He looked at himself in the mirror. His face glittered from the tiny glass particles that seemed stuck in every pore.

Chapter 6

In the parking lot after work, Tyrone had offered to cook Sonnie supper, and exhausted, she'd accepted. The traffic snaked slowly along the 110, and when they arrived at his place, he put two steaks on the grill and offered her a glass of wine. She refused and collapsed dazed on her stomach on his couch with an exhausted sigh. He played the album *If You Know Like I Know.*

The baritone voice of Teddy Pendergrass singing "Turn Off the Lights" soothed and calmed her. Tyrone heated scented oil in a stainless-steel pan and lifted the back of her blouse. She turned quickly and looked at him. He let her look in the pan, and she saw it was hot oil. She relaxed, letting him gently rub her back. She sighed again, this time with pleasure, and he kissed the small of her back. She said nothing, remaining still.

He climbed atop her and whispered his desires in her ear, but it sounded like a snake's hiss. She moved beneath him, indicating that she wanted to get up. He stood up, and

without looking at him, Sonnie walked to the balcony. She sucked in the night air, her back to him.

"I've been trying to mentor one of my clients," Sonnie said, speaking of Lisa. "I want to make sure she's prepared to take care of herself if her husband dies or leaves her."

"You are not your brother's keeper, Sonnie." Tyrone sneered. "It's every man for himself, so keep your clients at arm's length."

"Being detached is your specialty, not mine." She couldn't believe he was so irreverent and blasphemous as to challenge scripture.

"It's a survival tactic. If you're not detached, you go crazy."

"It cheats clients."

"No. You cheat yourself. You become stressed. Your body gives out. You become psychiatric. Your clients won't even remember your name." He waved his hands in the air.

"I'm not trying to please the administration. I'm not trying to get brownie points. I'm just trying to do the right thing."

"How do you know who you're trying to please? By now, their policies, their memos, their directives, their training sessions are clouding your decisions."

"Before I was trained, I read the Bible, listened to my pastor and developed a counterlife to life to departmental directives on how I should think and behave."

"Look. Is living your life to the fullest important?" Tyrone asked. "Is having fun and pleasure important? Is being happy important?"

"Like everybody, I want to be happy. I want to have fun, but I also want to have integrity."

"Ahh … integrity … respectability." He scoffed with a wave of his hand.

"Should I act like you? Come to work at ten, leave at three? Take two-hour lunch breaks, and write court reports without seeing my clients? Throw away all my telephone messages, pretend I didn't get them?"

"Should I try to be the man in child welfare families like you do? What does your counterlife say about that?"

"The fact that you didn't get to play pro ball bothers you, doesn't it?" she asked.

"Having a good time is the only thing that's important to me."

"And do people get misused while you're having a good time?"

"I don't know … But what I do know is that they're responsible for themselves."

"Does that mean you ran out on them when they needed you?" she pried.

"No, not necessarily," he said. "I tell people, women, I just want to have a good time. They decide if they want a good time or not. But they can always play it safe and avoid me."

"Then perhaps I should play it safe and go."

"Perhaps, but what you should be asking yourself is why you're leaving. Because you're afraid to enjoy yourself, to have fun, or to feel good … Are you afraid that when we're no longer interested in one another, you'll feel like a failure? Madness."

"Are you implying that I'm mad?"

"I was just questioning you," he said. "I was just asking you the questions you should ask yourself."

Her mind reeled, and she felt nauseous. Yes, she was afraid to have fun and feel good. She would feel like a failure if he moved on after he had toyed with her. She stared at him. She felt tired, as if she had been physically fighting with him. Slowly, she put on her shoes, picked up her jacket, and walked toward the door. Something in her wanted him to stop her, but he didn't. She opened the door and stepped outside. She heard the door click as tears fell down her cheeks.

"*Silly woman,*" she whispered to herself. "*Silly, silly woman.*" She stepped into her car and drove for miles before pulling over and stopping the engine. She was bewildered, so much so that she imagined herself to look like Annie Lee's *Blue Monday* painting. Was he right? Had she been selling herself short, assuming responsibility for her clients' problems? Shouldn't she live her life to the fullest?

She was about to turn her car around and return to his apartment, but she thought about her father's advice in the attic, after her affair with the poet. He'd said that a good man is one who makes you feel good about yourself. Tyrone had always done the opposite, and he had profaned scripture by saying she was not her brother's keeper. At last, she understood who Tyrone was. They were not and would never be compatible, perhaps a divine revelation.

She decided that she would never see him socially again, and she started her engine and headed for home.

A hamper stood in the middle of the hallway. Sonnie stepped around it and walked down the hall, peeking into

rooms where women in nylon nightgowns walked to cold, sterile bathrooms, holding their backs with one hand and their soft tummies with the other. As she approached a desk, a lemon-colored woman with black hair looked up from her charts.

"Yes, may I help you?" the woman asked, rolling her tongue sharply. Sonnie recognized her Tagalog accent and knew her to be from the Philippine Islands.

"I'm Ms. Black from Children and Family Services. I've come to get the Murdock baby."

"Please put on a smock and come around here. I'll show you how to mix his formula."

Sonnie put her purse and her briefcase on a chair behind the nurse's station. She slipped into the smock she was handed.

"This is his medication," a Filipina nurse said, handing her a little brown bottle. "This tells you when he should return for his first checkup." The nurse handed her a slip of paper.

"May I see the hospital social worker?" Sonnie asked.

"She's on her way up," the nurse replied. "I'll dress the baby while we wait."

A beanstalk of a woman, blond hair in a bun, appeared at the nurse's side.

"This is Ms. Simmons, the hospital social worker," the nurse said as she left to go into the nursery.

"Are you Ms. Black?" Ms. Simmons asked.

"Yes, I am," Sonnie answered, noting the woman's Scandinavian accent.

"Ms. Murdock left during the night a few days ago. She never returned or called."

"Did she give the name of the father?"

"No." The hospital social worker raised her eyebrows.

"Did she give the baby a name?" Sonnie asked.

"No." Again, the social worker raised her eyebrows. Sonnie mimicked the gesture.

"May I have a copy of the drug test for the court?"

"Yes, I made you one."

The Filipina approached Sonnie with the baby in her arms. Sonnie took the baby and examined his tiny face. He didn't wake up. She thanked the nurse and headed for her car. Many foster parents took special training classes to care for babies born with drugs in their systems, and they were paid $3,000 per month for their services. But Sonnie decided to take him to his grandmother's house, thinking she should receive the money.

Sonnie drove to the infant's grandmother's house, and as she opened the front gate, a pit bull ran toward her from the side of the house. She attempted to draw back, but the infant's diaper bag prevented the gate from closing. The dog leaped against the gate and snarled ferociously at her, exposing his sharp and jagged teeth.

"Prince, get down," the infant's grandmother yelled, grabbing the dog by the collar and pulling him away. She locked Prince in her garage. "I'm sorry, Ms. Black. I forgot he was loose. We had to get him after we were robbed a month ago. Took my TV, jewelry, and nearly everything they could carry."

Sonnie laid the baby on a couch—the same couch where she'd laid his sibling a year before. He continued to sleep. "It's a boy this time," she said to his grandmother.

"Did she name him?" his grandmother asked.

"No."

"Then that's our first task. Granddaddy, give this little one a name," she said to her husband. He sat in a wheelchair, unable to speak and paralyzed from a stroke.

"How many more babies, Ms. Black?" the infant's grandmother asked wearily.

"Let's hope this is the last one. Here's the paperwork for you to take to the welfare office to get him medical attention, and here is the date for his first appointment at the hospital."

"I just don't know how me and Papa gonna raise all these kids," she lamented, shaking her head back and forth.

"I know. I know it's hard on you." Sonnie put her arm around the woman's shoulders

The woman did not want her grandchildren to be taken to a foster home because she didn't want to give up on her daughter. Her daughter had been valedictorian in high school but had made only Ds her first year in college, even though she studied feverishly. Dismayed by her academic failure, she had begun to take drugs. Now she was homeless.

"Let's take a peek at our other little one," Sonnie said, standing. The woman rose and led her down a hallway to a back bedroom. The baby's sibling lay in a small, wooden crib. He was awake and followed them with his eyes. He didn't move or speak, and he couldn't walk. Sonnie listened to the grandmother lament about how busy her schedule was because both her husband and her grandson needed physical therapy. She commiserated with the grandmother for an hour before returning to her office.

The telephone on her desk was ringing as she entered the office, but the receptionist's head lay on her desk and she was

snoring. Sonnie raced to her desk and picked up the phone. A court officer indicated that a judge wanted a child taken to a group home because he was a fire starter and needed 24-hour supervision.

Looking at an apple and a small box of raisins she had intended for lunch, she sighed. She craved sugar and was on her way to the vending machines for jellybeans when her phone rang again.

"Ms. Black, this is Lisa. I need your help. I've got to get away and I don't have a bus pass or any money. Help me."

"What's wrong?"

"Frankie has blood all over him, and he says the police are after him."

"Where are you?" Sonnie asked. She jotted down the address. "I'll be there in twenty minutes." She ran to the parking lot and headed for the West LA address that Lisa had given her.

Once she arrived, Sonnie stepped out of her car and walked across the street, wondering whose house she was approaching. As she did, a man jumped from a white van parked in front of the house. He reached into his pants pocket and withdrew an LAPD badge.

"Who are you, and what business do you have at this address?" he asked.

"I'm Sonnie Black from Children and Family Services." She held up her county identification. "One of my clients called me." As she showed the officer her badge, she saw Frankie and Lisa being led out the front door in handcuffs. An officer carried Frankie Jr.

"You can take the baby into custody if you want, but both of the adults have to go with us," the officer said.

"But why?" She knew that the police department used an algorithm to judge people they came into contact with, and a first arrest would contribute to a future police profile of Lisa.

"We followed him from a warehouse where we found a fortune in cocaine. He's a dealer. He ruins their lives, ruins communities. He needs to go to jail, and that's where we're taking him." The officer sneered.

"But what evidence do you have that she's involved?" Sonnie asked.

"We'll have to question her to find out if she's involved in all this. That's why we're taking her with us." An officer put Frankie and Lisa into a police car and drove away.

Frankie Jr. leaned toward Lisa with his arms outstretched.

"Mama," he said, and tears formed in his eyes. Sonnie bounced him on her hip and then called his aunt to tell her that Lisa and Frankie had been arrested and that she would need to bring Frankie Jr. to her.

"Bring him on," his aunt said.

Chapter 7

"If you don't get along with your wife, you got to work around her," Howard's father said.

"You mean you find a lover as you have in Ms. Lee?" Howard revealed his knowledge of his father's affair, which had gone on for almost twenty years.

His mother's degree from Julliard and years as a dancer and choreographer for Alvin Ailey meant nothing to him. Her legs could no longer guarantee ticket prices. *How could he be so crude?* Howard wondered.

"What do you know about Ms. Lee?" his father said angrily. "Ms. Lee has been a good friend to me down at the court. She has helped me file my cases and prepare my briefs. That's all." His father walked across the room to the bar and poured himself a glass of bourbon.

"That's not all she does for you. Everybody knows about you and her. Don't try to deny it." Howard stood his ground. His father looked out of his son's large living room window at the Pacific Ocean and took a drink.

"You know the way your mother is. What am I supposed to do?" he asked soberly. Howard turned his back to his father and shook his head but said nothing.

"Give up all your radical defund the police, marijuana legalization ideas. That's the way you'll win your next district attorney race. Marry Serena, and if she makes you vomit, find a playmate who can keep your nature under control." He gulped the rest of his bourbon, scoffed, and slammed the door behind him when he left. His father had spent his retirement earnings trying to win two mayoral elections. Since he hadn't won either, he was now trying to live through Howard.

Howard looked in the refrigerator. Except for condiments, orange juice, and milk, it was empty. He kept it that way most of the time so that he wouldn't binge eat. He closed the door and walked to his balcony, looking at the Century City streetlights below. It felt like it was about eighty-five degrees. He looked at his watch. It was nine thirty at night. He'd been working on a case since he came home around five thirty. The case was to be heard in court the next morning. He worked too hard. He had always been that way, driven.

There was no breeze, no oxygen. Howard stared at his phone on his living room table and thought about calling Denice to get Sonnie's phone number. He wanted to properly apologize for the way he had behaved the night of the party. He laid his head back against the Corinthian leather couch. It felt soft and cool and made him remember the way Sonnie had kissed him—more passionately than he had ever been kissed. He desired to feel that way again.

He watched the Dodgers, but the game was moving too slowly, and he switched the channel to a trailer for a movie on the Playboy channel before turning the TV off. Listening to Will Downing's rendition of *Everything I Missed at Home*, he poured himself a vodka. Its taste reminded him of a puffy area that had recently appeared under his right eye, a sign of aging.

He tossed the rest of it into a metal sink attached to the bar and stood, looking up at the ceiling. The song made him feel sad, and he sighed. He decided that he should call Serena and ask her to dinner. He would follow his father's advice and propose to her. She was not the woman he wanted or needed. She was merely a means to an end—the DA's office.

A maître d' dressed in a black suit, white shirt, and red tie led them to a corner table quickly.

"Why do gay men have so much spit on their lips?" Serena asked. "It's absolutely disgusting to look at, especially when you're about to eat." Howard didn't answer her question. It seemed to be more of a statement. He ordered chicken cacciatore and a scotch on the rocks. She ordered shrimp scampi and a glass of white wine.

Half an hour passed before the waiter brought their orders. As he placed the dishes on the table, his hair flipped in his face, and he used his fingers to pull it back into place. Serena gasped.

"Did you see that?" she asked. "Just before he put your plate down on the table, he ran his fingers through his hair. That's disgusting. I'm not sure I can eat after that."

Howard loosened his tie. It was choking him.

"Do you have to do that? It makes you look unkempt," Serena said.

Howard tugged at the knot in his tie again and ordered vodka. She picked at her plate and timidly sipped her wine, not eating the rest of what she had ordered. She never really ate a meal. She just liked to taste food because she was always on one diet or another. When he had finished his meal, he paid the bill and they left.

"Want to go to my house for a minute?" he asked as they waited for his car.

"I don't mind," she said flippantly.

When they arrived at his place, he poured himself a glass of vodka and played Barry White on the stereo.

"Want something?" he asked.

"Cognac," she replied as she flipped through one of his *GQ* magazines, not making eye contact. He brought her a glass of cognac and sat next to her. He slowly began to kiss her cheeks.

"Come to bed," he whispered. She rose, walked to the bathroom, and closed the door. When she came out, she was naked. She slid into bed beside him. He was already naked. He turned over and climbed on top of her.

"I can't breathe," she said as soon as he began to rotate his hips. He leaned a little to one side and kissed her breast. She lay motionless, staring at the ceiling. Each time Howard tried to insert, she whimpered. When she was finally moist

enough for him to get up a rhythm, she put her hands against his chest.

"Your crotch hair is scratching me," she groaned. He slowed his rhythm. His head was next to hers, and he began to nibble her ear. "Your sweat is making my hair go limp." She wiggled underneath him.

He stood up and stumbled to the bathroom. He looked at himself in the mirror before opening the cabinet and reaching for a bottle of aspirin. He threw the aspirin into his mouth, walked back to the bed, and lay down as close to the edge as he could. He thought of Sonnie. Warmth flooded his loins as it had in her car on the night of the party. He inhaled deeply, sighed, and fantasized about what it would be like to make love to her.

Chapter 8

Sonnie took an aisle seat in the middle of the courtroom. She watched a bailiff in winter-green khaki pants and a beige khaki shirt move the hands of a large clock that sat in between the United States flag and the California flag. The bailiff repositioned the judge's brown leather chair, blew into the microphone, and straightened the judge's nameplate. Then he returned to his desk on the side of the courtroom.

After the county and the state had made teachers, nurses, and doctors mandated reporters who could be fined or jailed for not reporting suspected child abuse, the department and courts were flooded with cases. The sheer number of abuse and neglect cases overwhelmed both systems and legislators, who failed to provide counseling and parenting services. The problem became circular when the court ordered the parents to receive services when there were none.

Parents did not comply with the courts, and so the courts terminated their parental rights. All the while, lobbyists for group homes and foster mothers ensured that they benefited from the tragedy. Two flawed systems reigned

judgment on flawed people. Community courts like the one in Manhattan would have served South Central Los Angeles parents better than this computerized, docket-driven paper bureaucracy.

Lisa sat at a table in the front of the room, near the stenographer. Her hair was pulled away from her face into a tight bun at the nape of her neck. She wore pearl earrings, a navy suit with a white shirt, a tight skirt, stockings, and heels. A bailiff ushered Frankie in, hands cuffed. As Frankie entered the room, he stared at Sonnie for so long that he began to squint. Lisa turned and looked at Sonnie. The judge entered and pounded his gavel and called for order in the court. Frankie Jr. who was sitting quietly in Sonnie's lap with his finger in his mouth was startled by the sound of the judge's gavel and stood up on the bench and looked around the room.

"Mama," he said, twisting in Sonnie's arms.

The judge angrily looked at Sonnie. She grabbed her things and rushed for the door. In the hall, Sonnie rocked Frankie Jr. until he fell asleep. She noticed Denice and Serena emerge from a nearby courtroom. The two stopped near a courtroom door at the end of the hall. Serena held a document with one hand, pointed to it with the other and seemed to be explaining something to Denice when Howard emerged and joined their conversation.

Sonnie's pupils dilated. Perspiration formed on her forehead, and her heart began to pound in her ears. "Stop!" she told herself, trying to exert cognitive control over her emotions. She would not allow herself to feel gobsmacked ever again. Denice glanced in Sonnie's direction and then walked over to her.

"Sonnie, I think you should know that Howard asked Serena, who works in the prosecutor's office, to file charges against Tyrone. That's why I'm here today."

"Jesus," Sonnie exclaimed. "What happened?"

"It's a long story,"

"He's evil," Sonnie soberly replied. She squinted her eyes menacingly to emphasize her point.

"My sentiments exactly," Denice commiserated. "And he's one of the reasons why I'm leaving the department. But let's do lunch soon, and I will tell you what I hope he is found guilty of." She began to walk away, then she stopped and turned to Sonnie.

"Expect to get a wedding invitation from me. I've decided my county days are over. It's time for me to have some little piglets with James St. Clair, the minister who was at the party at my house. Cuz father knows best." She winked comically.

Always the clown, Sonnie thought.

Howard and Serena walked by them. Howard nodded at Sonnie, and as he did, Serena slipped her arm around his. *Serena has won the prize,* Sonnie thought to herself just as Howard released his arm from her grip, turned, and walked toward Sonnie. Her knees buckled which frightened Frankie Jr. who squirmed. She held him tighter.

"Sonnie, my church is going to build low-income communal housing, and we will need someone to counsel the residents of the housing complex. Would be interested in doing that?"

Sonnie was speechless.

"If so, we meet every Sunday at Pastor James St. Clair's house… It would give us a chance to get to know one another better."

"I'll think about it and let you know," she stammered.

"Good. Thank you." He bowed and walked away. Etta Jame's song *At Last* occurred to her, soothed her mind and helped her to cope with this sudden change of fate.

Well, there was a God after all, she thought.

The court doors opened. Frankie Jr. looked in the direction of the sound. Lisa stepped out, and he began to squirm.

"Mama," he cried. Sonnie released him. He waddled toward Lisa and wrapped his tiny arms around her legs. She lifted him to her breast, which he nestled in, closing his eyes as if he were going to sleep.

"The department's lawyer and the criminal court's lawyer worked on my case last week," Lisa said. "The two told the judge that since only Frankie and his partner were being charged, I should regain custody of this little one."

"Wonderful news. How about lunch?" Sonnie grinned. "We can talk about you becoming a small business owner. For example, you could start a childcare or elder care center."

"Frankie was trying to start a leather repair business but it never occurred to me that I could start one." She fluttered her eyes rapidly and thought for a moment. "What's the first step? Don't you have to have money first?" she asked guilelessly.

"My church helps people financially. So, I'll speak to my pastor about helping you."

Frankie Jr. put his fingers in his mouth as Lisa bounced him gently. Sonnie patted his nose with her forefinger. He

smiled, showing his baby teeth. He was safe, but he had no father. What kind of man would he grow up to be? Sonnie decided he should meet her father—a man who helped her and made her feel good about herself.

~

Stumps of trees served as guardrails on the dirt road, leading to the picnic grounds. Forest green trash barrels and toolsheds dotted the park, separated by cream-colored outhouses with brown roofs. The dusty hiking trails were not strenuous; they were made for retirees, overweight housewives, and sedentary office workers who backpacked on the weekends.

To the east, teenage blond girls groomed horses that were brought in by trailers hitched to sturdy pickup trucks. A field stretched the length of the park. One group of picnickers was playing football at one end of a grassy area. Another was playing volleyball at the other end. A pond was to the north of the field, and the highway back to the city or the beach was to the south.

Sonnie, her father, and her mother sat on top of a green wooden picnic table, waiting for her brother, his wife, and their daughter. The aroma of the barbecued ribs and chicken made them hungry. Her father had soaked the ribs in salt overnight to make them tender. Then he marinated them in sweet barbeque sauce and jalapeno peppers. Her mother used mayonnaise to make potato salad, adding onions, green peppers, eggs, and pickles to it. She also made pork and beans with maple syrup, butter, and black pepper, and sweet potato pie with sugar, cinnamon, and nutmeg.

A black SUV rounded the path that encircled the picnic area, and Sonnie's brother, his wife, and their daughter jumped out. They all gathered for hugs. Their car was followed by a dilapidated Nissan, which parked near her brother's car.

The driver was a man who wore faded jeans, high-top tennis shoes, and a long-sleeved shirt. The woman with him wore skin-tight jeans and four-inch spiked heels. Each of her numerous braids swung around her face. The woman put a bag of Kentucky Fried Chicken and two white paper plates on a wooden picnic table. The two began to eat, grease forming around their mouths. Sonnie's mother frowned and raised her eyebrows.

After eating, Sonnie's father placed hoops and pegs on the ground around them. Sonnie, her mother, and her sister-in-law played croquet while her father placed pegs in the grass farther away from him and her brother to play horseshoes. The man driving the Nissan opened the trunk of his car, exposing a tub of Budweiser. He handed two to her father and her brother, hoping they would invite him to play. They did. Her mother noticed that the woman was missing a front tooth. She was so shocked that she didn't ask the woman to play croquet. The woman began to play horseshoes with the three men.

"She gonna twist her ankle in them high-heeled shoes," Sonnie's sister-in-law whispered, irritated by the fact that the woman was enjoying herself.

"It's summertime. Why is he wearing a long-sleeved shirt?" her mother asked.

As the sun grew hotter, Sonnie's father turned his hat backward. Her brother's shirt hung out of his plaid shorts.

Both of their shirts were wet around their armpits. Their sweaty and disheveled appearances offended her mother and her sister-in-law, who rolled their eyes and clicked their teeth.

"I think I will go play horseshoes with Daddy," Sonnie said. She had overdosed on criticisms.

"You will not!" her mother hissed. Sonnie stood up but was not brave enough to further annoy her.

"Why not?" Sonnie confronted her mother for the first time in her life.

Her mother shook her head from side to side, sucked her teeth, and turned away. She couldn't articulate her prejudices. She was unconscious of them. Playing horseshoes in the summertime made you sweaty, and looking sweaty was lower class. She was embarrassed to say this aloud because it would reveal she was both a saint and a sinner.

"I think I'll see what my niece is up to. My friend should be here soon. She drives a Honda Fit. Point her in our direction. We'll be down at the pond, catching frogs."

"Catchin' frogs?" her mother asked. "Why would catch frogs? You'll both get dirty. Why don't you try to get her to take a nap? She's been in the sun all day." Her mother was referring to the fact that her niece's skin color had changed from the color of cinnamon to that of coffee.

"Mother, vitamin D builds children's bones and teeth, but it can't do it without the sun," Sonnie sharply replied, looking her mother directly in her eyes.

Her mother stood speechless and open-mouthed, shocked by Sonnie's tone. Momentarily, Sonnie stood her ground, ready to finally have it out with her mother, but embarrassed by her tone with her mother, she turned

and walked toward the trunk of her car. Opening it, she withdrew two empty pickle jars and two long-handled nets. She waited for the cars to go by so she could walk to the sidewalk where her niece was playing jacks. While she waited to cross, she lamented the disrespectful tone.

Could it be true that her mother believed in *The Curse of Ham*? Did she believe there were three races of people and that one race, the darker race, was less than the other two? Did she know that this interpretation of the story was made up by racists who wanted to justify slavery? Whether she knew it or not, it was important for her niece to know the Bible was written by mere mortals who interpreted portions of the Bible to justify discriminating against dark skin people. It was important for her niece to have a counterlife. Sonnie crossed the street to where her niece was playing jacks by herself.

"Want to catch some frogs?" Sonnie asked her niece, wondering if this was the time to tell her about the Bible.

"Frogs?" her niece asked.

"Yeah, cute, little baby ones."

Her niece jumped up and down, clapping her hands with excitement. Sonnie handed her a net, and they descended a small hill behind the picnic tables to a pond. The clear blue afternoon sky began to turn yellow and red as the sun began its descent. Sonnie heard her father walking through the brush to the pond.

"Show Granddaddy what you caught," Sonnie said to her niece, who stood in mud up to her knees. The little girl held up her jar filled with small frogs.

"Well now, looka here," her father said, deliberately exaggerating his Southern accent. It was something he used

when he was relaxed and away from her mother's critical eye. He noticed that Sonnie and his granddaughter had taken off their shoes and that their legs were covered with mud. His wife would disapprove when she saw the two of them, but they reminded him of the way women looked in Louisiana when they hunted for crawdads, searching in the mud for their evening meals.

"You know your momma gonna squawk like a crow when she sees you, don't you?" he asked.

"But you'll protect us from her. Won't you, Daddy?" Sonnie grinned at him.

"Momma don't mean no harm." He sat down and took his shoes off. "Momma's family was so 'respectable' that they never had no fun. Momma's scared to have fun. That's all. Can't blame folks that's scared." He slid his feet into the mud, wiggled his toes, and grinned broadly.

Sonnie loved her father, a dark chocolate man with high cheekbones and massive amounts of tight kinky hair. Her mother had not been successful at diminishing his worth in her eyes.

"Sonnie, your friend is here," her mother called to her. As Lisa descended the hill, her mother stood, shaking her head and sucking her teeth. She was revolted by the mud all over Sonnie and her granddaughter. With Frankie in her arms, Lisa descended the hill.

"So sorry I'm late, Ms. Black," Lisa said, handing Frankie Jr. to Sonnie. Sonnie kissed him on the cheek, put him on her hip, and walked him over to her father.

"Hey, little man," her father said. He took Frankie Jr. from Sonnie. The baby put his fingers in his mouth and

looked at his mother. "Can I take his shoes off? I want him to see how wonderful this mud feels between his toes."

Lisa looked at Sonnie, who nodded her head.

Her father took the baby's shoes off and set him in the water, feet first. Frankie Jr.'s hands held onto her father's pants as he looked up at him and smiled, showing his two front baby teeth. A butterfly fluttered above their heads, going from one limb to another. A frog hopped out of the water, and Frankie Jr. squealed with delight.

"Thought you'd like frogs," her father said. He smiled, completely charmed by the baby. He handed Sonnie's net to Lisa. "Competition to see who can catch the most. I'm betting you can outdo these amateurs." He encouraged Lisa to join them.

"That's right. Always bet on me," Lisa grinned at Sonnie's father and dipped a net into the water.

Learning to Love Yourself is the Greatest
Love of All – Whitney Houston

Bibliography

Addams, Jane. *Democracy and Social Ethics*. New York: Macmillan, 1902.

Beardon, Romare. *Two Women*. 1981-1982. Serigraph.

Da Vinci, Leonardo. *The Last Supper*. c. 1495–1498. Tempera on gesso, pitch, and mastic. Santa Maria delle Grazie, Milan. https://cenacolovinciano.org/en/.

Day, Dorothy. *Dorothy Day: Selected Writings*. Orbis Books, 2005.

Gilberto, Astrud. "The Girl from Ipanema." *Getz/Gilberto*. With Stan Getz and João Gilberto. Composed by Antônio Carlos Jobim. Lyrics by Vinícius de Moraes (Portuguese lyrics) and Norman Gimbel (English lyrics). Recorded March 1963. Released May 1964. Produced by Creed Taylor, A&R Recording, Verve.

Gorelick, Kenneth (Kenny G). "Songbird." *Duotones*. Recorded 1986. Released March 1987 (United States), August 1987 (Australia). Arista. Produced by Kenny G., Narada Michael Walden, and Preston Glass.

Holliday, Jennifer. *Dreamgirls*. Written by Tom Eyen and Henry Krieger. Recorded 1982. Released 1982. Geffen. Produced by David Foster.

Jamison, Judith. *Cry* (ballet). Premiered New York City Center, 1971. https://pressroom.alvinailey.org/alvin-ailey-american-dance-theater/repertory/cry.

Jones, Mona Lake. "A Room Full of Sisters." In *The Color of Culture*. 2nd ed. Impact Communications, 1993.

Lawrence, Jacob. *The Migration Series, Panel No. 57: The Female Workers Were the Last to Arrive North*. 1940–1941. Casein tempera on hardboard. The Phillips Collection.

McClurkin, Donnie. "We Fall Down." *We All Are One (Live in Detroit)*. Released December 2, 2008. Verity Records.

The O'Jays. "People Keep Tellin' Me." *Ship Ahoy*. Written by Kenneth Gamble, Leon Huff, and Anthony Jackson. Recorded October 3, 1973. Released April 1974 (United States). Produced by Gamble and Huff, Sigma Sound Studios, Philadelphia International.

Pendergrass, Teddy. "Turn Off the Lights." *If You Know Like I Know*. Released June 23, 1979. Written by Gamble and Huff. Produced by Gamble and Huff.

Shange, Ntozake. *For Colored Girls Who Have Considered Suicide / When the Rainbow Is Enuf.* With Oz Scott, Lindsay Law, Alfre Woodard, Lynn Whitfield, Scott P. Doniger, and Baikida Carroll. West Long Branch, NJ: Kultur, 2002.

Simone, Nina. "Four Women." *Wild Is the Wind.* Recorded 1965. Released April 1966. Produced by Hal Mooney, Philips Records.

Systems of Care. https://en.wikipedia.org/wiki/Integrated_care.

Wraparound Social Services. https://www.cdss.ca.gov/inforesources/cdss-programs/foster-care/wraparound.

Questions for Book Club Readers

Colorism / Featurism / Texturism:

1. Sonnie is gobsmacked by the poet and Howard. Is she suffering from a psychiatric disease?
2. Is being a role model like Sonnie powerful enough to combat colorism in our society? Consult chapter 8.
3. How does Sonnie's mother perpetuate colorism and how does Sonnie's father combat colorism?
4. What is your defintion of a good man?
5. Which type of prejudice is harder to overcome – colorism, featurism or (hair) texturism?
 Consult the following:
 https://www.theguardian.com/lifeandstyle/2019/apr/09/colorism-racism-why-black-people-discriminate-among-ourselves

https://99percentinvisible.org/episode/the-hair-chart/
https://mcsmrampage.com/2021/01/feature-colorism-featurism-and-texturism/

Child Welfare:

6. Do you think colorism, featurism and texturism should be considered (emotional) child abuse? If so why and should child welfare workers, police, and dependency judges be involved with such cases?

7. Should courts order parenting classes and drug abuse counseling if they are unable to determine whether such services are available or proximal?

8. If county child welfare departments assigned social workers to the areas where they currently lived, would that improve their casework?
 Consult the following:
 https://upendmovement.org/
 https://time.com/6168354/child-welfare-system-dorothy-roberts/
 https://imprintnews.org/child-welfare-2/dorothy-roberts-new-book-calls-for-foster-care-abolition/64727

Other

9. What role does Christianity play in colorism, featurism, and texturism?

10. Did allusions to artwork contribute to either character or story development? How about songs, poems, plays, and dance?

About the Author

Edwina Dorch
Writer, Artist, and Color-Therapy Coach

Edwina L. Dorch is a PhD psychologist who lives on a barrier island off the Florida coast. She is also a contemporary, abstract, minimalist artist who paints figures as well as landscaped, seascapes, and cityscapes. She is an art therapy coach who believes creating art is a type of coping mechanism that facilitates resilience and the capacity to recover from setbacks. It is also a way to manage stress and anxiety, to relax and release pent-up emotions. Her paintings appear in a number of Galleries of Local Artists along the Florida A1A highway.

Printed in the United States
by Baker & Taylor Publisher Services